The Book of Trades in the
Iconography of Social Typology

by HELLMUT LEHMANN–HAUPT

Delivered on the occasion of the

first annual Bromsen Lecture

April 28, 1973

BOSTON

Trustees of the Public Library of the City of Boston

1976

Maury A. Bromsen Lecture
in Humanistic Bibliography, No. 1

Library of Congress Cataloging in Publication Data

Lehmann-Haupt, Hellmut, 1903–
 The book of trades in the iconography of social typology.

 (Maury A. Bromsen lecture in humanistic bibliography;
no. 1)
 1. Amman, Jost, 1539–1591. 2. Sachs, Hans, 1494–1576.
Das Ständebuch-Illustrations. 3. Occupations in art.
I. Title. II. Series.
NE1150.5.A45L43 769'.4'930155 76–8399
ISBN 0–89073–010–5

Foreword

The Boston Public Library is indebted to Maury A. Bromsen for establishing an endowed lectureship in humanistic bibliography in memory of his mother, Rose Eisenberg Bromsen (1885–1968). The donor, a Boston scholar in the fields of Latin American bibliography and history, founded the rare book and manuscript firm which bears his name.

The lectureship was created "to invite annually a distinguished scholar to deliver a public lecture in the field of bibliography" and the advisory committee appointed to select the speaker included John Alden, Keeper of Rare Books and Manuscripts, Boston Public Library; Professor David S. Berkowitz, Brandeis University; Dr. Stephen T. Riley, Director, Massachusetts Historical Society; Professor Francis M. Rogers, Harvard University; and Rollo G. Silver.

Dr. Hellmut Lehmann-Haupt, an international authority in the field of the history of the graphic arts, was selected to give the first lecture in the series. His slide lecture on "Social Typology in Renaissance Book Illustration" dealt with the Dance of Death, Books of Trade, Books of Fools, and Physiognomy, all portraying Renaissance conceptions of everyday

life. In adapting his lecture for publication, Dr. Lehmann Haupt has dealt with the theme of Books of Trade since th aspect of his talk has not been developed as fully in the liter ature as the other topics.

Dr. Lehmann-Haupt has served as Curator of Rare Book and Assistant Professor of Book-Arts at Columbia Universit Research Associate in the History of Science at Yale Unive sity, and Professor of Bibliography and Consultant on Rar Books at the University of Missouri. He is the author of *A English 13th Century Bestiary*, *The Terrible Gustave Doré*, *O Hundred Books about Bookmaking*, *Peter Schoeffer of Gernsheim an Mainz*, *Art under a Dictatorship*, *The Life of the Book*, and *Guter berg and the Master of the Playing Cards*.

We are pleased to add the first Bromsen Lecture to this lis

PHILIP J. McNIFF
DIRECTOR AND LIBRARIA

The Book of Trades in the Iconography of Social Typology

STRICTLY SPEAKING it is not bibliography that I as bringing to you this evening. I have learned to define bliography as the effort to determine when was what written and printed by whom and where. That is not really what am about to discuss tonight. The term "humanistic," on the her hand, does apply to my lecture. This is, I presume, the ason why those who invited me allowed me latitude in the terpretation of "Humanistic Bibliography," for which I am ateful.

Humanism can roughly be defined as man's new concern ith man, as it took shape in fourteenth-century Italy and pread through Europe in fifteenth- and sixteenth-century re-aissance and reformation. What I intend to discuss with you one aspect of social typology in the book illustration of the naissance. I believe this has not been presented in this fashn before. To be sure, parts of the general picture of social pology will be more or less familiar to you. But the under-anding of these varied phenomena as closely related symp-ms of man's understanding of his social position is, I believe, new approach.[1] Also, the term "social typology" is a new

1. There have hardly been any studies of the hierarchy of professions, ades, and crafts in mediaeval and early modern times. The only real eatment of the topic I know is a paper entitled "The Social Order—

I

one for which I must accept personal responsibility. The wo "typology" by itself has a number of meanings. In art histo we usually understand by it the iconographic juxtaposition Old Testament prophecy and New Testament fulfillment, in the Biblia Pauperum (the Poor Man's Bible) and the Sp ulum Humanae Salvationis (the Mirror of Human Salv tion.) By "social typology" I mean a mirror of society wi emphasis on the stratification of man in the various estat from Emperor and Pope to beggar and prostitute—the va ety of human occupation from astronomer and alchemist papermaker, weaver, and itinerant peddler.

In some way the phenomena which can be seen in sha focus in the high renaissance all have more or less clearly o finable antecedents. But the point is just this that after th varied ancestry we see the themes so clearly and—from artistic point of view—so superbly expressed in the sixteer century. There is also the fact that each of these focal sta ments could not have had such a strong influence well in our own century, if they had not been expressed with su clarity and force at the beginning of our modern world.

The classic example of social typology is the Dance Death. While it enhances the understanding of human so ety as subject to a rigid stratification, it also and if you wish paradoxically—shows death as the great equalizer. Thus the very threshold of modern imperialism we find the conce of democracy enunciated with terrifying graphic power.

Next to the Dance of Death we see the neatly arranged a delightful images of man as a laborer earning his daily bre

Vocation and Obligation," by Mrs. Donald Chrisman of Northampt Mass., which she wishes to designate as "work in progress." Then there a historical study of the dishonest trades in central European traditi which is worth consulting—it is Werner Danckert's *Unehrliche Leute: verfemten Berufe* (Bern and Munich: Francke Verlag, 1963). Also to considered in this connection is Jill Mann's *Chaucer and Medieval Est Satire* (Cambridge University Press, 1973).

in the Book of Trades. Death is no longer present here. It is the skill of carefully cultivated craftsmanship that is celebrated. But the brittle quality of life on earth, the threat to social security of man appears promptly on the scene. In the Book of Fools we see humanity, not classified by occupation but rather by preoccupation, castigated by folly.[2]

To discuss all these facets would go beyond the limits of the present publication. I shall therefore concentrate on one aspect of social typology, namely, the Book of Trades. In order to avoid misunderstanding let me please explain that this is not an attempt to list and describe all publications fitting into this category, but rather to discuss some of the most important representations of the group.

The first regular Book of Trades is also in many ways the most interesting and graphically distinguished one (plate 1). It has 139 woodcuts by the masterful Jobst Amman and was published in Frankfurt on the Main by Sigmund Feyerabend in 1568, just thirty years after Holbein's Dance of Death appeared. There can be little doubt that Amman knew this epoch-making monument of social typology, as can be seen from a glance at its contents. The Book of Trades appeared in the same year in two editions, a German one with text by the famous shoemaker-poet Hans Sachs, entitled *Eygentliche Beschreibung Aller Staende auf Erden . . .* , and a Latin one with text by Hartmann Schopper, entitled *Panoplion* (Greek) *Omnium illiberalium mechanicarum aut sedentarium artium genere continens*, in other words, a description of the nonliberal, mechanical, and sedentary arts. The book, however, was by no means confined to the manual arts and crafts:

The philosopher came first, then the pope, the cardinal, the bishop, and the parish priest; emperor, king and princes; the

2. For some years the Library of the University of Missouri in Columbia has systematically collected examples of social typology in book illustration.

monk, the pilgrim to Compostela, the astronomer, the physician and the pharmacist, the advocate and the goldsmith. Next come the printing trades: the typesetter, designer, printer, engraver, paper maker, bookbinder, illuminator. After them come all the other arts and crafts, brewer, weaver, taylor, bell-caster, thimblemaker, clockmaker, baker, potter, and many more. The musicians, together with the soldiers, are at the end.[3]

Like the Dance of Death and the Book of Fools, the Book of Trades too has some late mediaeval forerunners, both manuscripts and incunabula.

There is, for instance, the *Tacuinum Sanitatis in Medicina*, a beautifully illuminated manuscript in the Austrian National Library. It was the "Housebook" of the wealthy Cerruti family, produced in northern Italy in the second half of the fourteenth century.[4] Actually, the manuscript is a combination of a herbal, with emphasis on the fruits, vegetables, grain, spices,

3. Quoted from a rare book catalog by William Salloch, Ossining, New York: Both the German and the Latin edition of Amman's Book of Trades were reprinted, again in the same year 1574. A further testimony to the popularity of the Amman woodcuts is their reappearance in the first and the second editions, 1641 and 1659, of Tommaso Garzoni's *Piazza-Universale: Das ist: Allgemeiner Schauplatz . . . aller Professionen . . . / Kuensten / Geschäften / Händeln Vnnd Hand-Wercken . . .*, Frankfurt on the Main, H. Polich & N. Kuchenbecker for heirs of Mathaeus Merian. It was illustrated with engravings and altogether 145 woodcuts (including some repeats) by Amman. Garzoni's work had previously appeared in an Italian edition without the Amman woodcuts under the title *Il Theatro de' varie diverse cervelle mondani*, Ferrara, Giulio Cesare Cagnacini, 1568.

4. Codex Vindobonesis series nova 2644, published in complete facsimile and with a separate commentary volume by the Akademische Druck-u. Verlagsanstalt Graz, Austria.

There is also a *Tacuinum Sanitatis* in the Bibliothèque Nationale in Paris. It bears the number "Novu. Acqu. lat. 1673." Also, we find illuminated certificates of various guilds in the Museo Civico in Bologna and in a manuscript in the Biblioteca Laurenziana, Ms. Temp. 3. The information in this paragraph is taken from Emma Pirani's *Gothic Illuminated Manuscripts* (London and New York: The Hamlyn Publishing Group, 1970).

4

tc., grown for a mediaeval household, and the various trades
and crafts furnishing all the necessities which a wealthy fam-
ly would purchase in addition to the homegrown produce. It
s rich and detailed, with large miniatures for each plant,
craft, and trade. The style could be described as "early mod-
ern," a combination of mediaeval pictorial traditions with
the new realism first developed in the fourteenth century in
Italy. We show here "the butcher, the baker, the candlestick
maker" (plate II).

There is one other illuminated manuscript, completed well
over a century after the *Tacuinum Sanitatis* in a fully developed
renaissance style with deep perspective and highly detailed
representations of arts-and-crafts objects and their tools and
production methods (plate III). It is almost a complete Book
of Trades. The manuscript is known as the *Cracow Behaim-
Codex*,[5] a collection of the privileges of the craftsmen of the
town of Cracow, including the regulations, the forms of oath,
and several coats of arms of the various guilds. The codex is
named after the town scribe Behaim, who completed the
manuscript c. 1505. Among the craftsmen we find the baker,
the tailor, the goldsmith, the cooper, the potter, and many
others.

Then there is at least one work printed in several editions
in the fifteenth century which comes very close to being a
Book of Trades. It is the *Speculum Vitae Humanae* by Rodericus,
Bishop of Zamora, who is usually known as Rodericus Zamo-
rensis. This is a highly moralizing description of the various
estates, beginning with the emperor and continuing on down
the line. Each estate is represented both in what we might
call "the state of grace" and in its state of corruption. A good
example is the notary (plate IV), whom we show in both con-

5. Friedrich Winkler, *Der Krakauer Behaim Codex*, mit einer rechtsge-
chichtlichen Studie von Johann Werner Nieman (Berlin: Deutscher
Verein für Kunstwissenschaft, 1941).

ditions in hand-colored woodcuts from the Augsburg, Günther Zainer edition of 1471 (Goff: R-215). The style of these woodcuts is the result of the early mass-production technique of the fifteenth-century Augsburg workshops.

The Amman woodcuts, by contrast, can be considered a very fine examples of mature, high renaissance book illustration. It so happens that they are followed by two Books of Trades which are characteristic examples of baroque graphic art. Both are illustrated by intaglio engravings rather than woodcuts. We have noted (see footnote 2) that the Amman blocks were used as late as 1659, a time when the woodcut began to yield noticeably to the intaglio tradition.[6]

We now come to a Book of Trades of both high aesthetic quality and great popularity, Jan and Caspar Luyken's series *Het Menselyk Bedryf* (Amsterdam, 1694). This very fine series was frequently reprinted under various titles.[7] The University of Missouri Library in Columbia owns the edition entitled *Afbeelding der Menschelyke Bezigheden* (Amsterdam: Reinier and Josua Ottens, c. 1720) (plate v).

The hundred pictures are arranged alphabetically, beginning with advocate, apothecary, and astrologer. Included among many others are baker, diamond cutter, coppersmith, shipbuilder, and several members of the book trades and industries, ending with the swordsmith (zwaardveger). The delightful etchings are cut with the use of firm but delicate outlines and with effective light and shade.[8]

6. The decay of the woodcut is generally considered to have set in with the beginning of the seventeenth century. I have demonstrated in my latest book (not yet published), *The Woodcut in 17th Century Prints and Book Illustrations*, that the seventeenth century still saw vigorous and artistically valuable woodcut production.

7. For an accurate bibliographical description of these editions see P van Eeghen and I. Ph. van der Kellen, *Het Werk van Jan en Caspar Luyken* (Amsterdam, 1905).

8. Jan Luyken, the father of Caspar, according to Thieme-Becker, was one of the most productive and at the same time one of the most many

Four years after the first edition of Jan and Caspar's Book
f Trades there appeared, in 1698, Christoff Weigel's beau-
ful and important *Hauptstände*. The full title of the book
ins: *Abbildung der Gemein-Nützlichen / Haupt-Stände / von denen
egenten / und ihren / so in Friends-als Kriegs-Zeiten zugeordneten
edienten / bisz auf alle Künstler und Hand wercker . . .* von Chri-
off Weigel / in Regensburg, . . . 1698. Like the Dance of
eath, the work includes all strata of society, from the regents
nd their "servants" down to the artists and craftsmen. Plate
ɪ shows the very skillful combination of descriptive accuracy
ith graceful composition in harmonious settings. The verses
re full of moral allegory with a strongly pietistic flavor. Un-
er the papermaker, for instance, we read (in rough and lit-
ral translation):

> Through diligence many an old rag is given back
> new usefulness—beautiful and white—
> Shalt thou my work remain contemptible?
> From old sinner's estate quite new and pure,
> So that God's hand may write his will on you.

By contrast, the German Hans Sachs' verses under the
mman cuts were simply straightforward verbal descriptions
f the professions and procedures depicted above. The Chri-
off Weigel (1654–1725) mentioned on the title page of the
aupstände was both an enterprising publisher and an illus-
ator in his own right. Nevertheless, he copied for his book,
me in reverse, a large number of etchings from Jan and
aspar's *Het Menselyk Bedryf* (cf., e.g., the Printer in plates v
nd vi).

The replacement, in Luyken's Book of Trades, of the older
ierarchic arrangement of estates, professions, and trades by
n alphabetical one is more than an arbitrary variation of a

ded etchers of the Dutch school. He was one of the few important Dutch
aphic artists who achieved distinction after Rembrandt.

traditional theme—it is the reorientation towards a growing interest in the lower strata of society. This becomes very clear when we look at a specialized variety of the Book of Trades namely, the "Street Cries." This is a large group of rather attractive and interestingly illustrated series describing the costumes and wares of itinerant peddlers and street merchants and their various cries. We all know the popular song Molly Malone in Dublin's fair city, "crying cockles and mussels, alive, alive, oh!"

The "street cries" began to be published in the course the seventeenth century and reached their climax of popularity in the eighteenth and early nineteenth centuries, in other words shortly before, during, and soon after the French Revolution. The *Katalog der Lipperheideschen Kostümbibliothek* (Berlin, 1965) lists some fifty such publications.[9] Described there are four seventeenth-, twenty-three eighteenth-, and eighteen nineteenth-century examples. Twelve of them are French eleven German, ten Italian, six English, four Russian, and three each Swiss and Austrian. There were also some reproductions of earlier "cries" in the late nineteenth and early twentieth centuries.[10] It is a pity that limitations of space prevent us from getting better acquainted with these attractive and socially illuminating productions of graphic art.

The Age of Revolutions, which had such varied and profound effects on literary and artistic culture of the western world, influenced the Books of Trades too, in a very special way. The nineteenth century witnessed a vigorous new interest in the nearly four-hundred-year-old tradition, especially in France.

9. See volume II under "Ausrufe" in the "Schlagwort-Register" (Catchword Index). The listings in this catalogue, by the way, are by no means complete. See also Karen F. Beall, *Crier and Itinerant Trades / Kaufrufe Strassenhändler: A Bibliography* (Hamburg: Hauswedell, 1975).

10. See also Marion Elizabeth Dean, "The London Street Crier and His Musical Cries" (M.A. thesis, University of Missouri, 1966).

However, before discussing this fascinating new movement, brief word is to be said about two nineteenth-century Eng- h Books of Trades, which had nothing to do with the new evelopments just mentioned. In contrast to the poetic, alle- orical, and moralizing character of the older examples, these vo are decidedly pedestrian, practical, and strictly utilitar- n. Here are the titles of the two books: *The Book of English rades, and Library of the Useful Arts, with seventy engravings . . . ith 500 questions for the exercise of students* (12th ed., London: rinted for Sir Richard Phillips and Co. [1824]; and *The ook of Trade, or Circle of the Useful Arts* (13th ed., London: rinted for Griffin, Bohn & Co., 1861). The former has medi- re wood engravings, the latter rather nice steel engravings d wood engravings.

These two books, obviously very popular, are really voca- onal guides for young people of the lower middle classes. We e reminded in library history of the establishment, in the rst part of the nineteenth century, of town and school dis- ict libraries, and mercantile, mechanics', and apprentices' braries in England and America.

We now come to the amazing and fascinating renaissance the Book of Trades in France in the first half of the nine- enth century. Obviously, the French Revolution had cleared e way for these socially oriented statements, and in the days Louis Philippe, the Bourgeois King, it was only natural at the life of the middle classes moved into sharp focus. The markable thing was that these richly illustrated works were ighly sophisticated, very often satirical, and produced by aphic artists of highest rank. Their universal medium was e wood engraving, performed by highly skillful designers nd engravers who had assimilated Thomas Bewick's late ghteenth-century invention to the Parisian scene of the ghteen forties.

The pièce de resistance of this group is a massive, nine-vol-

9

ume, large octavo set entitled *Les Français peints par eux-mêmes Encyclopedie morale du dix-neuvième siècle* (Paris: Curmer, 1841). With truly encyclopedic scope the set does not describe only trades, crafts, and professions, but also representatives of various social groups, including many women, and hobbies, pastimes, and sports. The first volume alone includes, among others, the baker, the law student, the respectable matron, the literary debutante, the political debutante, the "Femme à la mode," the actress' mother, the gardener, the duchess, the doctor, the collectors, "La grande Dame de 1830," the deputy, the chess player, the hunter, the chambermaid, the employee, the housewife, the fruit vendor, the traveling salesman, and the speculator.

There is a most elaborate index, listing for each piece the author, the illustrator or illustrators, and the wood engraver; each listing is preceded by a delicate postage-stamp-size reproduction of the portrait at the beginning of its chapter.

Each essay starts with a full-page illustration on the left page (plate viia) and with a headband and title vignette on the right; there is also a tailpiece at the end and sometimes a text vignette neatly placed in the type area.

Among the numerous authors we find such luminaries as Balzac, Théophile Gautier, and A. Delacroix. The list of illustrators includes almost all the great names of the eighteen forties: Daumier, Garvarni, Grandville, Johannot, and Monnier.

Les Français peints par eux-mêmes was not only a resounding success in France, but it also elicited similar publications in other countries. Editions appeared in Spain, *Los Españoles pintados por si mismos* (Madrid, 1843–1844); Mexico, *Los Mexicanos pintados por si mismos;* and Russia, *Nashi spisannyes natur* (Moscow, 1841) (plate viib).[11]

11. See my article "Russische Buchholzschnitte 1840–1850," in: *Gutenberg-Jahrbuch* (Mainz, 1932). I said there (in my translation): "The life of

We also have a number of publications which deal mono-raphically with only one trade or profession each. The most amous of these is François Fabre's *Némésis Médicale Illustrée* 2 vols., Paris, 1840), illustrated with numerous wood en-ravings after Honoré Daumier, his most important contri-ution to book illustration. The satire is very bitter (plate IId), a veritable catalogue of malpractice cases. But the doc-or is also shown sympathetically, bandaging wounded sol-iers on the battlefield and defying sleet and rain on the way to some rural patient.

Daumier also produced a remarkable collection of litho-raphs, bound and issued as a book: Alhoy and Huart's *Les Cent et un Robert-Macaire* (Paris: Aubert, 1839–1840). This is a very special Book of Trades. The "hero," Robert-Macaire, is hown as a super-conman, thug, and crook all in one. We see him incorporating a long list of criminal types: bank robber, imposter, antique faker, swindler, etc. Here is a monument to an unavoidable stratum of society.

Whereas the *Némésis Médicale* was a large octavo two-volume work devoted to a single profession, there appeared also in the eighteen forties, published by Aubert, a series of small volumes c. 9 × 14 cm) each devoted to a single profession, the famous "Physiologies." They were written and illustrated in a hu-norous and satirical vein by much the same authors who were responsible for *Les Français peints par eux-mêmes*. This se-ies of delightful little volumes included, among many others, the *Physiologie de l'Etudiant*, the *Physiologie du Théâtre*, the *Phys-iologie du Musicien*, and James Rousseau's *Phsyiologie de la Por-*

he Russian people in all its color and variety is the subject of this work, which describes the many classes and professions with amiable attention to their characteristics. The illustrations are produced in the same spirit with which many aspects of the Russian folk characters are characterized in a superb manner. To be sure, there is a lightly sarcastic attitude here, but the humor is never without affection or understanding."

tière (Paris: Aubert, 1841). The latter, describing the molelik
existence of the superintendent's wife, is perhaps the most fa
mous of the lot. It is illustrated with a large number of smallisl
and delicately cut wood engravings after Daumier (plate
viic).

We have reached the end of the road.[12] There seem to have
been no illustrated Books of Trades published after the mid
dle of the nineteenth century. Unlike the Dance of Death
which reaches well into our own period, the branch of socia
typology identifiable as the Book of Trades does not seem to
have survived the impact of the industrial revolution. The
computer programmer, the photographer, the aviator, and
the television operator so far have remained unheralded in
terms of the six-hundred-year tradition which we have traced
in this lecture.

12. A word of gratitude is due to a number of helpful librarians and
printroom curators, and in particular to Ms. Elisabeth E. Roth, in charg
of the New York Public Library Printroom, to Dr. J. W. Niemeyer, Di
rector of the Printroom of the Rÿksmuseum in Amsterdam, and to Pro
fessor W. J. Bouwsma at Berkeley.

PLATES

Fuſor literarius. Der Schrifftgieſſer.

CAlcographis fundens ex ære fideliter omnes
 Literulas, conflo quaslibet arte notas.
Siue Latina meum, ſeu Gallica lingua requirit
Officium, Doctis pareo ſponte viris.

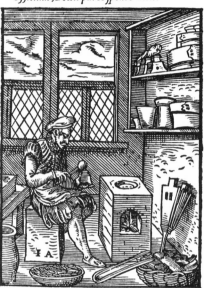

Ipſa mei paßim quoq Græcia muneris arte
 Indiget, egregios cùm premit ære libros.
Hæc foret ars noſtra niſi tempeſtate reperta,
 Nunc mihi ſcribarum functio quanta foret?
Plura breuis ſpacio quia ſcripta Typographus horæ
Edit, quam multis ſcriba diebus agat.

Adum-

Faber. Der Schmid.

EN candens ferrum dum forcipe ver..
 Bracchia magnificis viribus vſa ..
Non ſine me celeres aurigæ nouit haben.
 Currus, in acceſsus aut valet ire vias

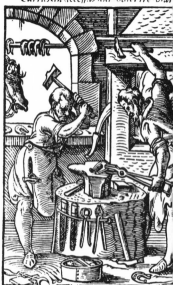

Non agilis vacuum rota curreret vlla per..
 Ante meam ſi non experiatur opem.
Excußis neq liber equus volat vllus habe..
 Vngula ni dextram ſentiat ante meam..
Adde quod et morbos releuem ſapienter
 Malleus & ferrum mulceat omne meu..

I. The Typefounder, the Smith, the Thimble M..
 and the Vintner. Woodcuts by Jobst Amma..
 Hartmann Schopper, *Panoplion* (Frank..
 Sigmund Feyerabend, 1..

ta verecundis digitalia fingo puellis,
 Quæ gerat in digitis sedula virgo suis.
tenues docto percurrit pectine telas,
gibus & rarum munus adornat acu.

VInitor obliquas industrius alligo vites,
 Et vineta mea sedulus arte colo.
Deciduam valido compescens robore vitem,
 Fronte superuacua luxuriare veto.

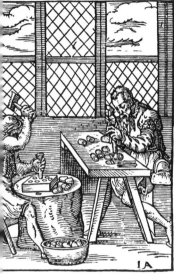

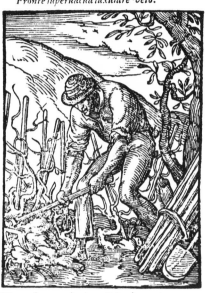

repræsentat festus quod gesta tapetu,
 quæ nimis artifici sunt bene ducta manu.
r & sartor digitalibus, vtitur omnis
tor, & haud nostræ respuit artis opem.
men emptor de millibus elige multis,
nueniat digito quod digitale tuo.

Lami-

Terra frequens herbis, vligine lætaq; dulci
 Pascit opus limo conueniente meum.
Is facit, vt plenum mihi grata det vua liquorem,
 Et vetulos onerent feruida musta cados.
Vinetis nimius nisi falx mea deputet vmbras,
 Nulla sub autumni tempore vina bibes.

Textor.

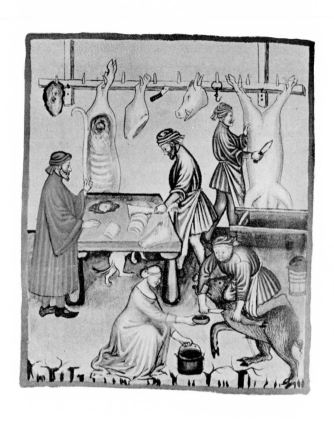

II. The Butcher, the Baker, and the
Candlestick Maker in the
Tacuinum Sanitatis.

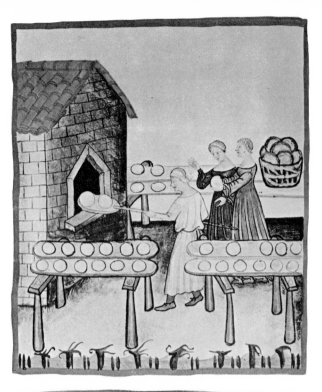

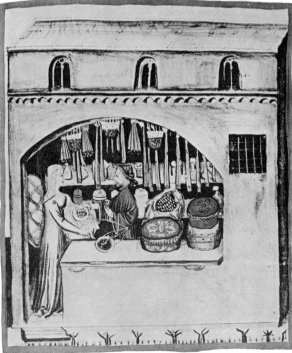

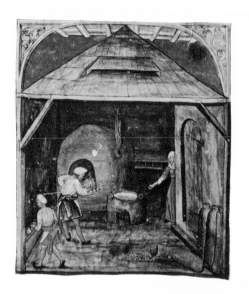

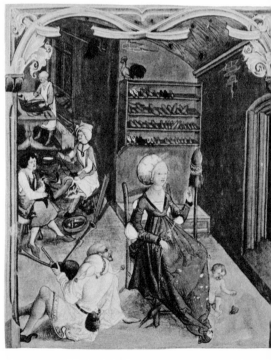

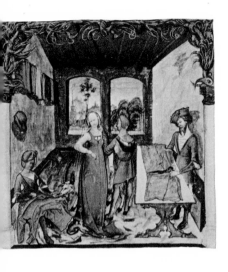

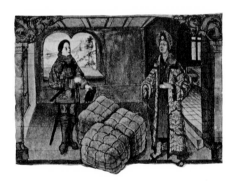

III. The Baker, the Shoemaker, the Taylor, and
the Merchant in the *Cracow Behaim-Codex*.

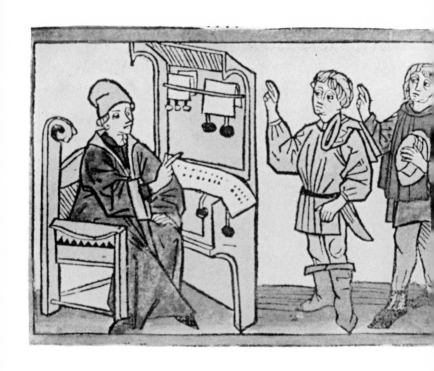

IV. The Notary in the "state of grace" (above) and the "state of corruption" (right) in Rodericus Zamorensis, *Speculum Vitae Humanae* (Augsburg: Günther Zainer, 1471).

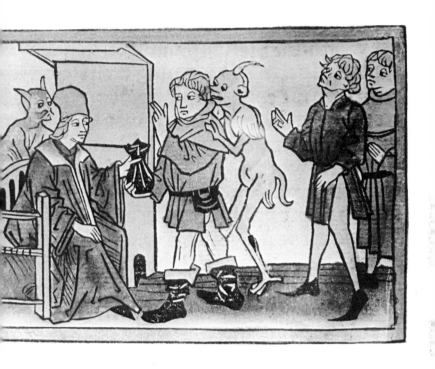

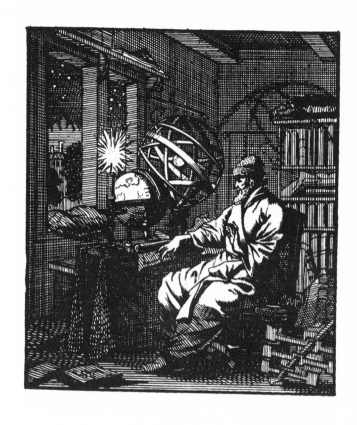

V. The Astrologer, the Sculptor, and the
Printer in Jan and Caspar Luyken,
Afbeelding der Menschelyke Bezigheden
(Amsterdam: Reiniers and
Josua Ottens, c. 1720).

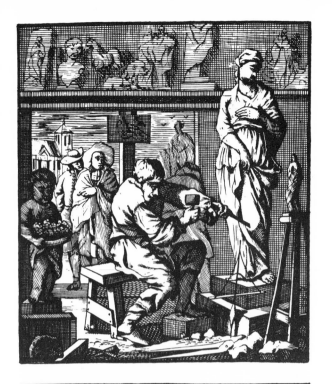

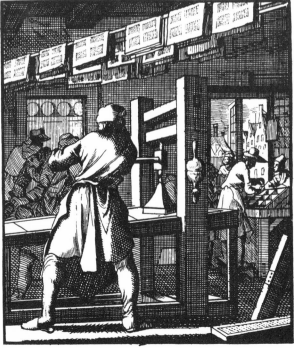

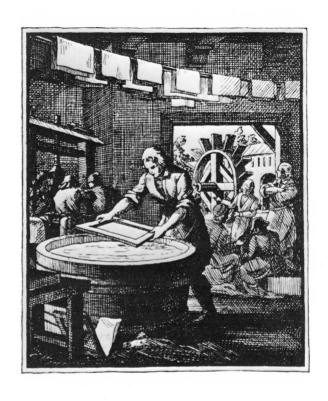

VI. The Papermaker and the Printer
in Christoff Weigel, *Abbildung der
Gemein-Nützlichen Haupt-Stände*
(Regensburg, 1698).

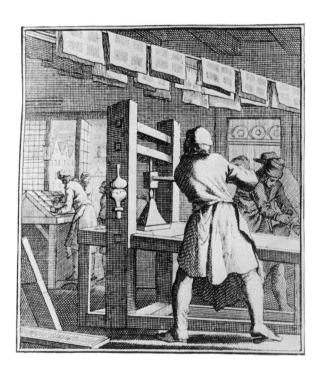

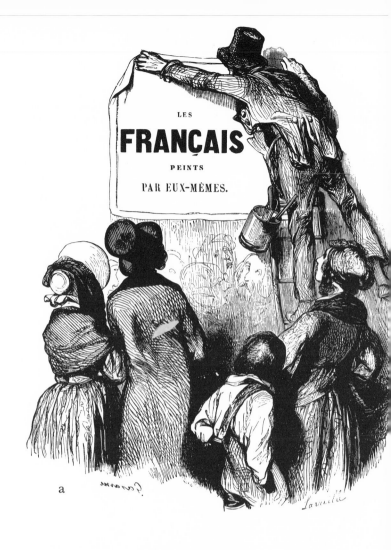

a

b

c

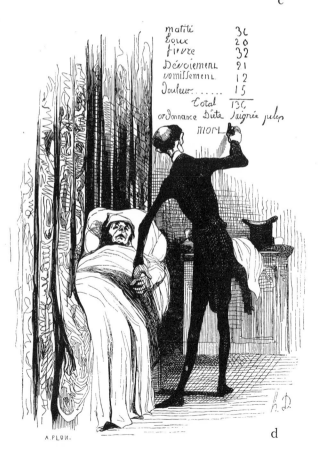

d

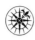

One thousand copies designed and
set in type by The Stinehour Press and
printed by The Meriden Gravure Company
on 80-pound Caress Text, Colonial White

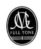